PAUL GAUGUIN

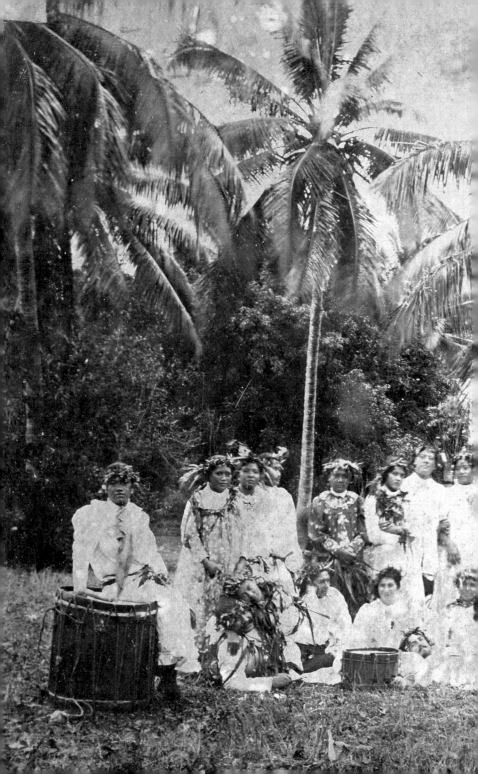

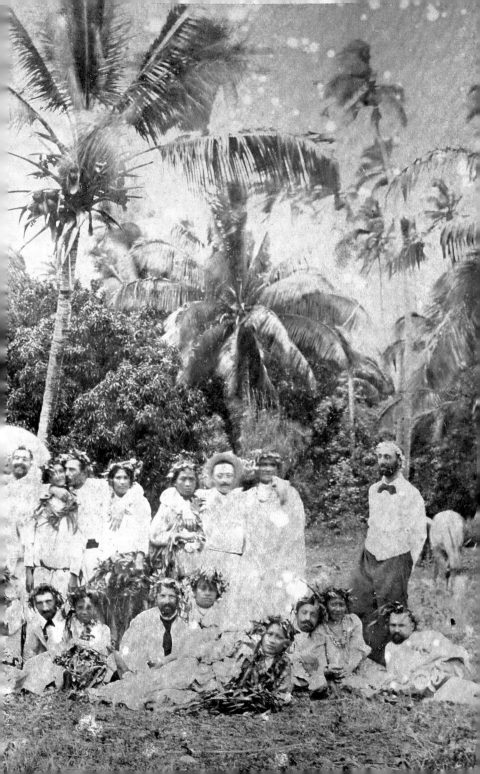

PAUL

GAUGUIN

WITH CONTRIBUTIONS BY
Isabelle Cahn and
Eckhard Hollmann

HIRMER

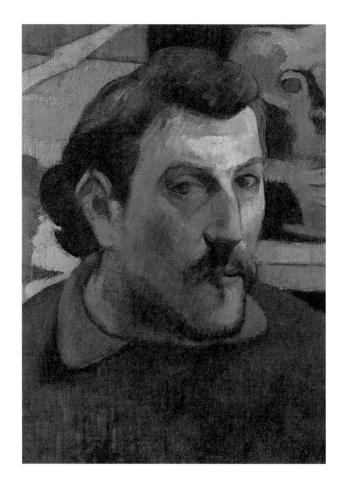

PAUL GAUGUIN

Self-Portrait with Yellow Christ, detail, 1889

Oil on canvas, Musée d'Orsay, Paris

CONTENTS

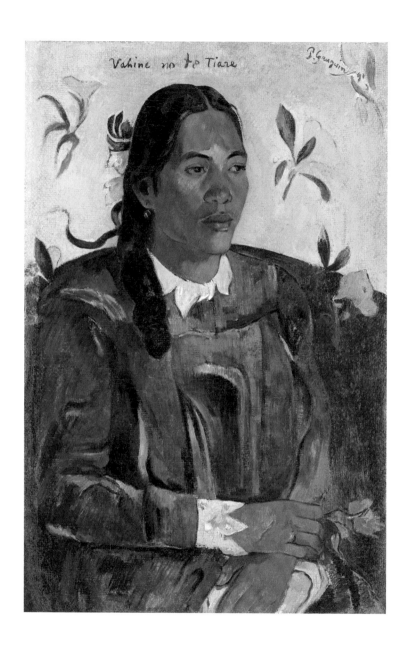

I *Vahine no te Tiare (Woman with Flower)*, 1891
Oil on canvas, Ny Carlsberg Glyptotek, Copenhagen

THE FIRST STAY IN TAHITI, JUNE 1891–JUNE 1893

Isabelle Cahn

The flesh is sad, alas! and all the books are read.
Flight, only flight! I feel that birds are wild to tread
The floor of unknown foam, and to attain the skies!

Stéphane Mallarmé, *Sea Breeze*
In memory of Françoise Cachin, who showed us Gauguin's Eden

EN ROUTE TO "THE FIFTH WORLD"

On 1 April, 1891, Paul Gauguin left Marseille for New Caledonia on "L'Océanien", via the Suez Canal, the Seychelles, Adelaide, Melbourne and Sydney. Having hesitated at length over his destination, he had finally chosen Tahiti, a French protectorate. Armed with an official letter from the Ministry of Public Instruction and the Fine Arts he had obtained a reduced-rate, second-class ticket from Paris to Noumea from the Compagnie des Messageries Maritimes. According to the ministerial order issued on 26 March 1891, "the painter M. Gauguin is charged with a mission to Tahiti, to study the customs and landscapes of this country from the point of view of art and the pictures to be painted of it." The civil servant had merely copied what the artist had written on the administrative form.

The decision to leave came at a key moment in his career. At the height of his creative powers and already famous within a clan of avant-garde artists, he had emerged as the leader of the anti-naturalist movement and acquired the aura of a master among painters such as Emile Bernard and Paul Sérusier and also established artists such as Van Gogh and Redon. An article by Albert Aurier, published in March 1891, attests to his position as a leader of Symbolist painting.[1]

Gauguin was now almost forty-three. He had a little money from the sale of his studio[2] and the meagre funds raised by a benefit performance for himself and Verlaine, organised by Paul Fort, director of the Théâtre d'Art. But with his sturdy character, innate authority, cut-and-dried opinions and brutal witticisms, the artist had not made only friends and admirers in the art world.[3] His self-assurance also got on people's nerves. Photographs taken before his departure by Boutet de Monvel, show him in a relaxed pose, wearing an embroidered Breton waistcoat beneath his jacket, a sartorial touch showing his penchant for distinction and originality. The pose also brings out his famous 'Inca' profile which, he said, explained the atavistic origin of his aspiration towards a primitive world and his singular behaviour. "It's the basis of my personality," he explained. "I try to confront rotten civilisation with something more natural, based on savagery."[4] There is also a self-portrait (2) in a striped fisherman's smock from this period. Gauguin's questioning look, with his hand holding his chin rather like Rodin's *Thinker* (1880–81), evokes this period of uncertainty before his departure.

On 23 March, a banquet with Mallarmé as master of ceremonies officially launched the Oceanian adventure. Some forty representatives of the world of the arts and letters applauded the poet's first toast: "Messieurs, to get straight to the point, let us drink to Paul Gauguin's return, but not without admiring the superb consciousness which in the brilliance of his talent, to test himself, exiles him in distant climes and in himself."[5] One of Boutet's photographs (p. 70) was stuck to the back of the menu guests kept as a souvenir.

Fear that his inspiration would run out of steam, the desire to escape the "literary hacks"[6] and itchings for the unknown, sum up Gauguin's state of mind in the spring of 1891. The civilised world and its artifices disgusted him. He aspired towards a more authentic world that would enable him to experience true sensations and sentiments, to express his fears and desires.

2 *Self-portrait with Figure of a God*, 1891
Oil on canvas, McNay Art Museum, San Antonio

En route for "the fifth world", as seamen called it, beyond which "there is no possible further flight except for the next world"[7] he was embarking on an adventure with no return, that some contemporaries already considered pointless. "One creates so well at Batignolles," Mallarmé had exclaimed.

IN SEARCH OF THE TAHITI OF OLD

After a voyage of over two months, Gauguin disembarked at Papeete on 9 June, 1891. His dream of an Eden preserved, as it had been described by Bougainville and Melville, rapidly evaporated. Papeete was a small provincial town and sub-prefecture with a large European community. Yet Gauguin sought support there and met the Governor and Director of the Interior, hoping to obtain "a few well-paid portraits"[8] and make a name for himself as an artist in this narrow-minded world that preferred more conventional talents.

His hopes were further dashed by the death of King Pomare V on 12 June. As the last representative of the royal dynasty, he had embodied the final bastion of resistance to the power of the colonists and missionaries. "With him died the last vestiges of Maori tradition," Gauguin acknowledged: "With him Maori history ended. Civilisation, alas! – army rabble, trade, officialdom – was triumphing. A profound sadness took possession of me.

To have come so far to find the very thing I was fleeing! The dream that brought me to Tahiti was cruelly belied by the present: it was the Tahiti of former times that I loved."[9]

This realisation, echoed by Victor Segalen when he arrived in Tahiti ten years later, was irrevocable: the island was dying.[10] And the painter would express this disenchantment in works drawing on the full power of this nostalgia.

Portrait commissions were rare and life in town was unbearable, so Gauguin decided to leave Papeete for more artistically simulating surroundings. He moved to Mataiea, a village on the ocean forty-five kilometres south of the capital. In this new environment, he was moved by the daily spectacle surrounding him there and his artistic project began to take shape. "I have done nothing outstanding yet," he acknowledged, "I'm content for the moment with searching myself, not nature, with learning a little to draw …"[11]

The Tahitians' charm, nonchalant poses and impenetrable facial expressions fascinated the painter and he made numerous charcoal and watercolour studies for future pictures,[12] in which he tried to convey their overall character. His Tahitian *vahine*, Teha'amana, a fourteen year-old local girl with very marked Tahitian features, became his favourite model. She has a gentle face and thick hair which the charcoal accentuates. In these mask-like portraits her pupils are not drawn in. Neighbours also posed for him. "In order to familiarize myself with the characteristics of a Tahitian face, to the all the charm of a Maori smile," he recounted à propos of *Vahine no te Tiare* (1): "I had wished for a long time to do a portrait of one of my neighbours, a young woman of pure Tahitian extraction … I asked if I could do her portrait. She pulled an incensed pout, abruptly said 'Aïta', (no) and off she went … An hour later she returned in a beautiful robe … Caprice, desire for the forbidden fruit. She smelt fragrant and she was all decked out … She was not pretty according to our European aesthetic rules, yet beautiful. All her traits combined in a Raphaelesque harmony in the meeting of the curves, her mouth had been modelled by a sculptor speaking all the languages of the kiss, joy and suffering; the melancholy of bitter experience which lies at the root of all pleasure … It was a portrait resembling what my eyes *misted by my heart* perceived. I think above all that there was an inner likeness … She had a flower behind her ear, which listened to her perfume."[13]

Although under his model's spell, Gauguin still allowed himself a modicum of interpretation, as he had done in Brittany with *La Belle Angèle* (24). The hieratic pose taken from Egyptian painting,[14] the musicality of the colours and the naïve simplicity of the surrounding flower motifs, imbue the portrait with a poetic charm in perfect harmony with her melancholy gaze.

Gauguin, who like Edgar Allan Poe, admired strange rather than conventional beauty,[15] did not try to correct defects according to the European aesthetic criteria of his time. At the beginning of his stay, he painted two pictures[16] illustrating the taciturnity of Tahitian women,[17] entitling them *Faaturuma*, a term now translated as "sulky" but also meaning "melancholy" or "reverie". In the list of the first Tahitian pictures sent to France,[18] he translated the title as *Silence or Gloominess*. The version in the Nelson-Atkins Museum of Art (3) shows a Tahitian woman sitting in a rocking chair, wearing a long "missionary" dress[19] and lost in a daydream. The picture by Gauguin of a *fare*[20] on the wall behind her has since disappeared, or may have been imagined by him for the composition. By placing it well in evidence, Gauguin was evoking the erosion of the traditional Tahitian lifestyle by western civilisation, represented by her dress and the furniture in the room. Rocking the chair with an imprecisely drawn foot, the woman is soothing her melancholy, with the inertness of her immense hands forcefully expressing the inevitability of the situation.

Gauguin was surrounded by docile models who could personify his nostalgia for a bygone tropical world and the withdrawal into itself of a race on the verge of extinction. He gave most of his pictures Tahitian titles in the form of a question, as if to better convey the uncertainty of a future compromised by the invasion of western civilisation. The confrontation between two worlds is blatant in *Tahitian Women* (4). The picture depicts two women – although Teha'amana probably posed for both – one wearing a *pareo*, the other a "missionary" dress. They are sitting on a terrace or beach, as indicated by the title later given to the picture. The tightly-framed, close-up view of the figures accentuates the scene's strangeness. The woman on the right is plaiting palm fibres to make a hat. But why this sombre air in such an Edenic setting, in a scene treated in a decorative vein, with vivid colours and undulating lines ? Gauguin was satisfied with the result. " … I'm beginning to understand the Oceanian character," he wrote to his wife[21] "and I can assure you that what I'm doing here has been done by nobody, and that it is unknown in France." This progress in his

recherches prompted him to prolong his stay: "I'm hard at work, I now know the earth, its smell, and the Tahitians, whom I do in an enigmatic way, are nonetheless Maories and not Batignolles orientals. It has taken me almost a year to manage to understand this ..."[22]

A LAND OF DELIGHTS

At Mataiea, Gauguin lived in a *fare* in close proximity with the village's inhabitants. He observed their daily life, noted their gestures, studied their language,[23] steeped himself in the rhythm of their daily life and savoured an existence entirely devoted to his art. "My life now is that of a recluse," he wrote to Monfreid.[24] The portraits conveying "the Maori soul" were soon followed by village scenes and sumptuous landscapes expressing his wonder at the beauty of tropical nature, its brilliant colours and strange forms. The excessiveness of its elements is manifest in the two versions of *Te Raau Rahi (The Big Tree)*, in which the trees extend beyond the edges of the canvas. With these framings arbitrarily truncating the subject and his use of non-realist colours – red earth, yellow palm trees, coral-coloured flowers – Gauguin avoided two stumbling blocks: photographic accuracy and dulcified descriptions à la Pierre Loti.[25] His landscapes, the stuff of dreams as much as direct observation, disconcerted rational western sensibilities when they were shown for the first time in Paris in 1893.[26]

"I have seen trees that no botanist would find, animals that Cuvier never imagined and men that only you have been able to create, a sea seemingly flowing from a volcano, a sky uninhabitable by any God", lamented Auguste Strindberg.[27] To which Gauguin replied: "This world that perhaps neither Cuvier or a botanist could find, is a Paradise that I have merely sketched out. And between sketch and the realisation of a dream lies quite a gulf ... Never mind!"[28]

The New Cythera painted by Gauguin is comparable to the biblical Eden in its representation of luxuriant nature and the carefree existence of its inhabitants (5). Men carrying *feii*,[29] women resting in the shade of trees (6) and conversations are shown as moments in a life outdoors in which man lives from fishing and gathering. Late in 1891, Gauguin painted women carrying fruit beneath the pandanus with a dog (7). The composition combines natural elements and figures in artificial poses evoking a

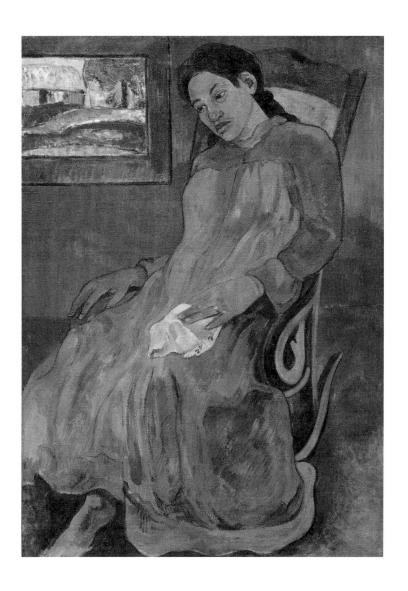

3 *Faaturuma (Melancholy)*, 1891, oil on canvas
The Nelson-Atkins Museum of Art, Kansas City

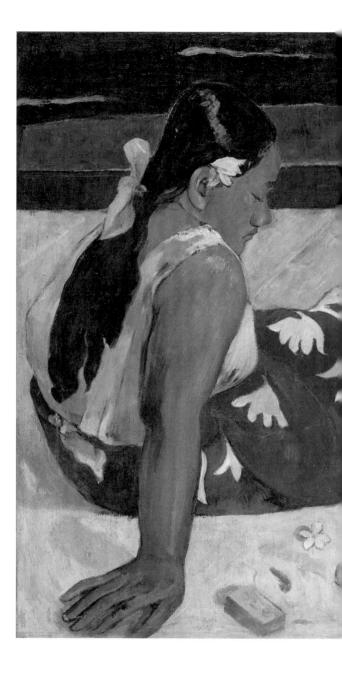

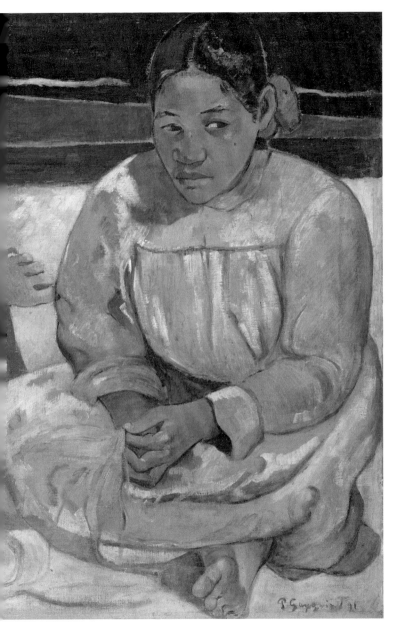

4 *Femmes de Tahiti/Sur la Plage (Tahitian Women/On the Beach)*, 1891
Oil on canvas, Musée d'Orsay, Paris

chance meeting or a conversation in an idyllic setting. The vivid colours and decorative arabesques amplify the harmoniousness of the Tahitian paradise, in which anecdote often takes second place to the landscape itself, as in both versions of *Mahana Maa* (*The Moment of Truth*; 8).

Tahitians believe that nature is inhabited by invisible powers and spirits and these beliefs govern their daily life. Gauguin, whose imagination was steeped in the fantastic visions of Edgar Allan Poe and Redon, was drawn to these superstitions expressing the irrational side of human nature. He gathered information about them and studied the island's ancient religion in order to integrate this new knowledge into his work.

"In the evening, he attends meetings. He listens to the stories of the elders, sets the sublime poetry of the legends in his mind and joins in the choir of improvised chants, while the sea purrs softly in the distance, in the intertwining twilight branches, and the scent of the flowers rises from the earth about to go to sleep. Then, little by little, through these tales and this

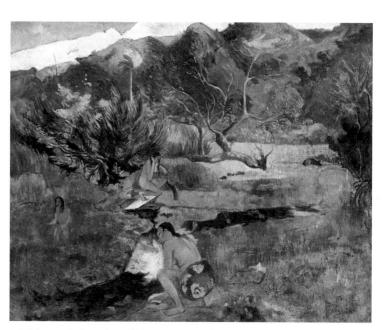

5 *Tahitiennes près d'un ruisseau (Tahitian Women Beside a Stream)*, 1893
Oil on canvas, private collection

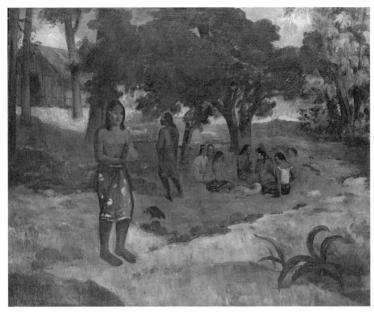

6 *Parau Parau (Whispered Words)*, 1892
Oil on canvas, Yale University Art Gallery, New Haven

music and the constant beauty filling his eyes, the beauty of the prodi-
giously living landscape, the beauty of the human body, of its dark golden
flesh and idolic poses, the entire past of this miraculous land of idleness,
grace, harmony, power, naivety, grandeur, perversity and love is evoked in
the present."[30]

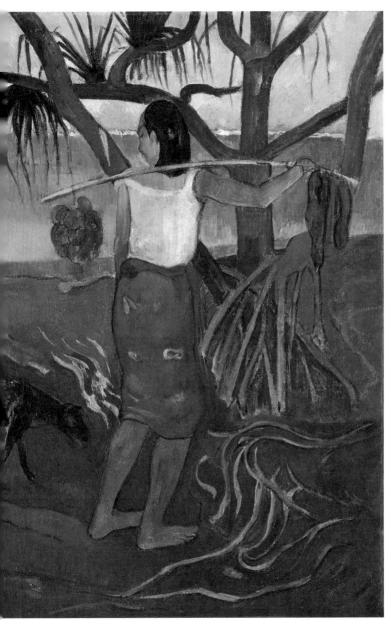

7 *I raro te Oviri (Under the Pandanus)*, 1891
Oil on canvas, Foundation for the Arts Collection, Dallas Museum of Art

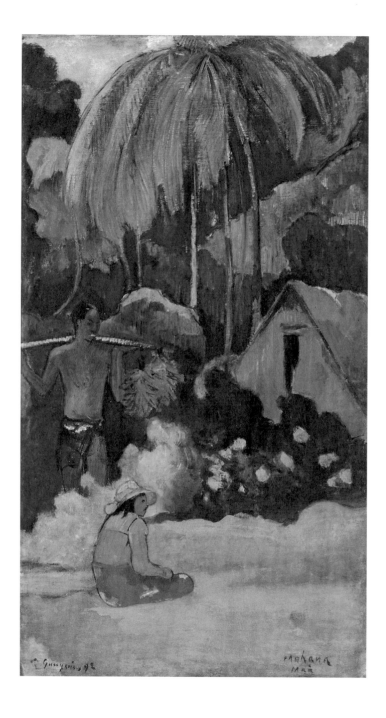

"WHAT A RELIGION THE ANCIENT OCEANIAN RELIGION IS. IT'S MARVELLOUS!"[31]

The proselytism of the Protestant and Catholic missionaries had long since eliminated ancestral beliefs and myths in the name of monotheism. "Shall I manage to recover any trace of that past, so remote and so mysterious ... To get back to the ancient hearth, to rekindle the fire in the midst of all these ashes", Gauguin wondered.[32] His interest in the Oceanian myths has to be seen in the context of an intellectual trend that found its formal quintessence in Symbolism. The esotericism of the Rosicrucian Order, the resurrection of the heroes of Valhalla by the Wagnerian movement, and the interest of Scandinavian artists in the Kalevala were part of this rediscovery of epic legends as the foundations of national identity and power. But rare were the Europeans who then regarded the civilisations of "primitive" peoples as equal to theirs.

The dark-skinned savage was not considered a descendant of Adam and his place in creation remained an enigma alongside that of the Christian white man. Relying on their literal interpretation of the Bible and belief in the superiority of their technological and cultural inventions, westerners justified the hierarchy of races and the colonial model.[33]

At the beginning of his discovery of the ancient Maori religion Gauguin was torn between his own cultural references and his quest for syncretism. An initial picture, which he said he was "quite happy with",[34] depicts a Tahitian Madonna with an angel with large yellow wings behind a bush in bloom (9).[35] This novel vision, challenging the immutable image of the Italian or Flemish Virgin and blond Child, literally illustrates the transposition of Christian religious history into the Oceanian world. The demonstration is implacable and gave rise to one of Gauguin's most powerful and subtle paintings from both a compositional and chromatic point of view. Gauguin familiarised himself with Maori beliefs not, as he affirmed,[36] via his *vahine* but from a book. Maître Goupil, a notary in Papeete, lent him both volumes of *Voyage aux îles du Grand Océan*, published in 1837 by a

former consul in Tahiti, Jacques-Antoine Moerenhout.[37] Gauguin drew on this narrative, based on accounts gathered from the island's elders at the beginning of the century and Tahiti's rare archaeological remains, to give further form to the legends and myths he was discovering. The temples where human sacrifice was practised having been destroyed by Westerners, he drew inspiration from the few remaining stones of the coastal temple at Mahaiatea[38] and photographs of other *marae*[39] to paint the picture he entitled *The Sacred Mountain (Parahi Te Marae; There is the Temple* or *There Resides the Temple*; 10). The composition is not a faithful reconstruction but an imaginary evocation of the place of worship seen from outside the enclosure, inside which the uninitiated could not enter. On a hillside[40] entirely painted in the sacred colour yellow, stands a stone statue of a deity based on the model of the Tahitian *tikis*[41] or *ti'is*.[42] The Sino-Japanese-influenced design of the surrounding fence is freely copied from an ear ornament. The skulls placed at regular intervals evoke the site's sacrificial use. The complexity of these rhythmically repeated forms imbues the composition with a symbolic and decorative dimension. The picture also introduces the idea of an aesthetic of worship, confirmed by the extraordinary floral mound in the foreground. It was one of the works Gauguin sent for an exhibition organised via the intermediary of his wife in Copenhagen in March 1893.[43] In the version of *Noa Noa* reviewed by Charles Morice, Gauguin expressed the picture's dimension as a *memento mori* of a lost civilisation, "There is no doubt," he wrote,[44] "that human sacrifices once took place there. The painter shows the trace of this with fences on which remain the sculpted testimonies of skulls, vague and more terrible in their imprecision."[45] At no point in his œuvre did Gauguin indulge in graphic demonstration, preferring to evoke the sacred and defunct gods symbolically, through suggestion and dream. The monumental statue of *The Sacred Mountain (Parahi Te Marae)* towering over the landscape suggests the mysterious power of the god Taaroa and the minuteness of man in the universe. It expresses the very essence of Maori religion, based on the worship of the forces of nature and their personification as idols.

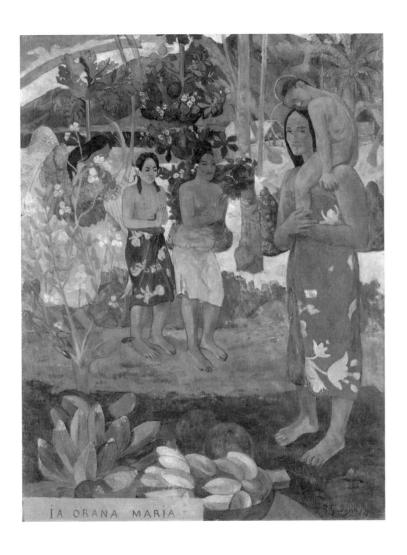

IA ORANA MARIA

9 *Ia Orana Maria (Hail to Thee, Mary)*, 1891
Oil on canvas, The Metropolitan Museum of Art, New York

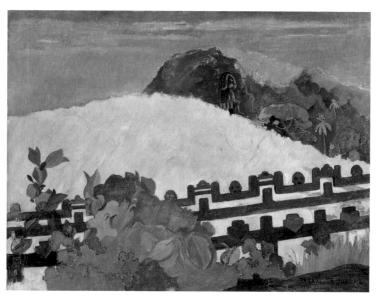

10 *Parahi te marae (There Is The Temple/The Sacred Mountain)*, 1892
Oil on canvas, Philadelphia Museum of Art

ANCIEN CULTE MAHORIE

In 1892, Gauguin copied passages from Moerenhout's book into an exercise book, the cover of which he reinforced with card and whose spine he bound with a machine-sewn chequered handkerchief. The album, entitled *Ancien culte mahorie*, was the first manuscript he illustrated with watercolours. He referred to it for paintings and sculptures with Tahitian mythological themes. The gods and heroes are shown in an enchanted, luxuriant world (p. 79). "Ta'aroa46 is the light; he is the seed, he is the root; he is the incorruptible, the power that creates the universe, the great and sacred universe that is only the shell of Taaroa."

Some of the manuscript's pages are abundantly illustrated and faithfully follow the description in the text, such as the legend of Hiro, god of thieves, who makes holes in rocks with his fingers and frees a virgin held captive under the spell of giants. His writing often passes over the watercolour, indicating that the illustrations were probably preceded by preparatory drawings, of which there is no trace (11).

As attested by the blank pages between the last text and the index, the manuscript was never finished. Gauguin never parted with it. It was bequeathed by Etienne Moreau-Nélaton in 1927, and is now in the Musée d'Orsay collection. Since a clause in the will forbids its loan, the water-colours have remained exceptionally fresh.

"THE SPIRIT OF THE DEAD WATCHING"

Although no picture stems directly from the illustrations of *Ancien culte mahorie*, Gauguin drew a *marae* in it.[47] Is this the crest of the sacred hill from which the *tupapaus*, the spirits of the dead, descend to haunt the balmy Tahitian nights?[48]

"This people traditionally has a very great fear of the spirits of the dead," Gauguin explained about one of his pictures, *Manao Tupapau (Spirit of the Dead Watching*; 12). It shows Teha'amana paralysed by superstitious fear of one of these spirits of the dead, depicted as a sexless, ageless being dressed entirely in black, sitting at the foot of her bed. Reddish glows emphasise the harmonious forms of her androgynous juvenile body. Fear of death

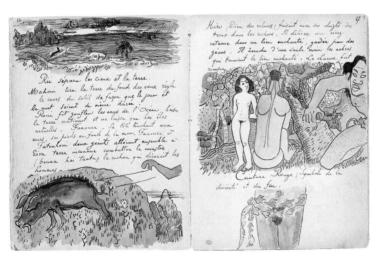

11 From the manuscript *Ancien Culte Mahorie*, 1892/93
Indian ink and watercolour on paper, Musée du Louvre, Paris

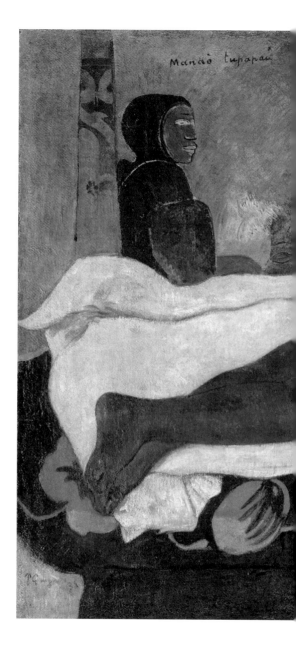

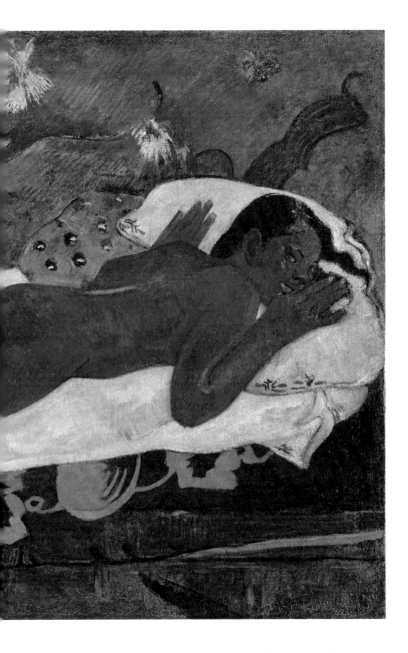

12 *Manao tupapau (Spirit of the Dead Watching)*, 1892
Oil on canvas, Collection Albright-Knox Art Gallery, Buffalo

and desire blend in the supernatural atmosphere created by this apparition. Gauguin mentions the genesis of this picture, which he valued greatly (49), in several of his manuscripts.[50] "I was obliged to go to Papeete one day. I had promised to return that evening, but the cart I took left me half way and I had to do the rest on foot, and it was one o'clock in the morning when I got back. We had only very little lighting at the time, as I had to renew my supply. When I opened the door, the lamp was out, the room was dark … I quickly lit matches and I saw… Tehura (diminutive for Teha'amana), naked, lying motionless on her stomach on the bed, her eyes inordinately wide with fear, looking at me and seeming not to recognise me."[51] The magnetic eroticism of this Oceanian nude evokes the sensuality of Manet's *Olympia*, a reproduction of which Gauguin had hung on the wall of his hut.

The beautiful Teha'amana is also the model in a picture with an allegorical dimension, *Merahi Metua No Tehamana (Tehamana has Many Parents*; 13). She is sitting rather stiffly, as if posing for a photograph, holding a type of plaited straw fan common on the island of Samoa and wearing a western-style dress with a collar and lace-trimmed cuffs. Behind her, there is a frieze of stylised figures of the principal gods of the Maori pantheon, including the moon goddess Hina.[52] According to ancient belief, the Tahitians stemmed from their union with the god Taaroa, the embodiment of the male spiritual principle. Priests once recited endless genealogies using a knotted cord rosary to ascend the long chain of filiation. In the decoration's upper register, Gauguin copied two lines of glyphs from a photograph of a *rongorongo* tablet, the mysterious writing of the inhabitants of Easter Island.[53] This iconographic commentary alludes to the mysterious origins of the Tahitian people and the importance of their religion. The picture may be referring to the Tahitian custom of adoption of children by the extended family. When Gauguin became betrothed to Teha'amana, she introduced him to her biological mother and her foster mother. He explained his surprise at this in his *Souvenirs*[54] but doesn't burden his pictures with any ethnographic demonstration of this.

Teha'amana represents the beauty of the Tahitian race. She embodies the sinless Eve, about to be tempted by the Devil in the Garden of Eden (14). But Gauguin was also fascinated by the legendary grace of Vairaumati (15), the young woman from Bora-Bora whom the gods chose as queen of the Areois, the secret society founded by the islands' first inhabitants. Her

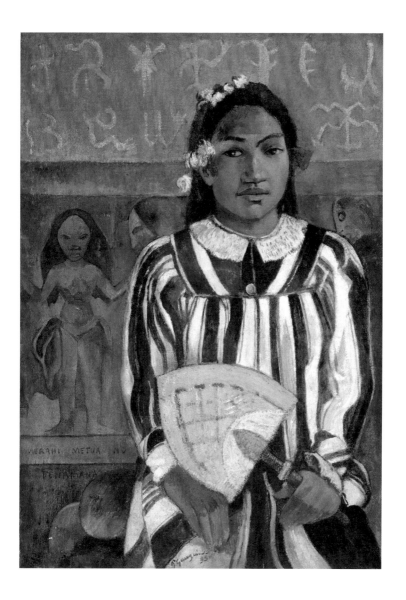

13 *Merahi metua no Tehamana (Tehamana has Many Ancestors)*, 1893
Oil on canvas, The Art Institute of Chicago

14 *Parau na te varua ino (Words of the Devil)*, 1892
Oil on canvas, National Gallery of Art, Washington

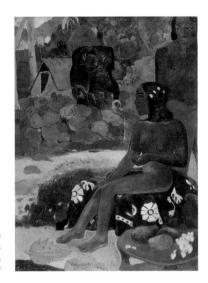

15 *Vairaumati tei oa*
(Her Name is Vairaumati), 1892
Oil on canvas,
Pushkin Museum, Moscow

descendants stem from her union with the powerful god Oro. Drawing on Egyptian stylisation, with head and legs in profile and bust face-on, and the position of Puvis de Chavannes' *Hope*,[55] Gauguin portrays her seated naked in a landscape, in the full radiance of her beauty. "… she was of great stature and the fire of the sun shone in the gold of her flesh, while all her mysteries of love lay dormant in the night of her hair."[56] She is holding the seed of the Areois in the palm of her hand.

"A FEW VERY WILD SCULPTURES"[57]

In October 1892, Gauguin ran out of canvas and turned to sculpture, producing works in the "wild curio genre"[58] and cylinders decorated with bas-reliefs. There was no shortage of wood of the right density on the island, *toa* (iron), *tamanu* and *pua* wood. His statuettes, stylised in the manner of Maori fetishes, are ambiguous. Are they idols or decorative objects? Several of these delicately carved figures reappear in monumental form in his paintings and woodcuts of religious subjects and also in the watercolour illustrations of *Ancien culte mahorie* and *Noa Noa*.

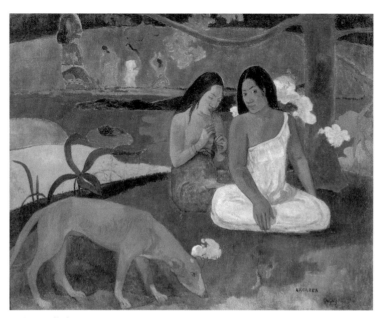

16 *Arearea (Joy)*, 1892
Oil on canvas, Musée d'Orsay, Paris

One of the first sculpted cylinders depicts Hina, the embodiment of the female principle, with other deities. The goddess's stylisation combines elements borrowed from Maori sculpture and others taken from Hindu statuary (the jewellery, belt and flower behind the ear).[59] The cylinder's phallic shape suggests the idea of fecundity. The artist uses this form to isolate the main figure whilst associating it with other elements in a spatial continuum. Parallel to his production of idols, Gauguin also decorated wooden crockery, bowls, goblets and *poïpoï* dishes. The ornaments sculpted in bas-relief, sometimes monochrome, are inspired by vegetation or the geometric lines of traditional tattoos.

Gauguin's *tiisi*[60], first shown in Paris in November 1893, were not greatly appreciated, due either to ignorance of the subject or lack of interest in their stylisation. For a long time they were regarded as a pastime, under-taken solely for the pleasure of sculpting.[61] But Gauguin still managed to sell 'two bits of sculpted wood' for 300 francs[62] during the exhibition. The artist's friends appreciated his freedom. In 1894, Daniel de Monfreid pro-

duced an etching after a cylinder Gauguin had just sculpted in Brittany. Its main subject is Christ on the Cross, surmounted with Maori heads and decorative motifs, while the cylinder's other surfaces are decorated with Polynesian gods and signs imitating the glyphs from Easter Island. This iconography, a daring synthesis of Catholicism and Maori religion, express Gauguin's desire for universality.

VIVO

As soon as he arrived in Tahiti, Gauguin was captivated by the *hymenées*[63] sung at King Pomare's funeral. "It seemed to me that I was listening to Beethoven's Sonata Pathétique," he wrote.[64] He depicted singers and musicians in several pictures evoking the mystery of nocturnal festivities and the sacredness of the *vivo* (16). "I am learning to know the silence of a Tahitian night. But the rays of the moon play through the bamboo reeds, standing equidistant from each other before my hut, and reach even to my bed. And these regular intervals of light suggest a musical instrument to me – the reed-pipe of the ancients, which was familiar to the Maori, and is called vivo by them – an instrument that remained silent throughout the day, but which at night by grace of the moon calls forth in the memory well-loved melodies".[65]

Unlike the sensual rhythm of the *upaupa*,[66] the archaic notes of the flute accompany peaceful visions of Tahiti before the colonial conquest (17). These biblically simple pastorals, were intended to please a blasé European bourgeois clientele. The musicality of the lines and colours takes precedence over realism, their powerful sonorities conveying a poetic vision that no chromolithograph by Loti, a writer Gauguin detested, had ever succeeded in capturing.

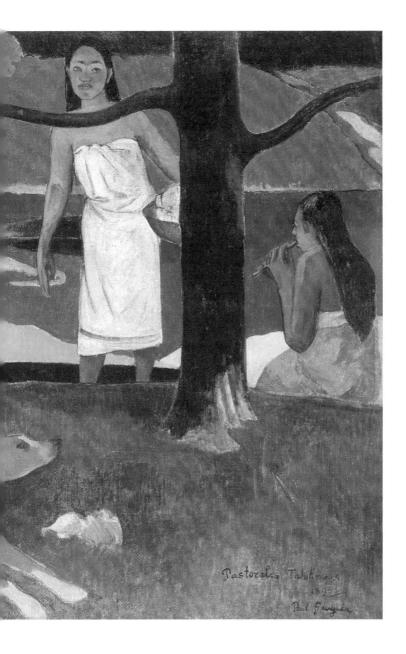

17 *Pastorales Tahitiennes*, 1892
Oil on canvas, Eremitage, St. Petersburg

To quench his nostalgia for Tahiti's mythical past, Gauguin reinvented history, drawing on ancient tales and superstitions. The myth of the still-cannibalistic island fired his imagination. He wanted to hear the stories of the last cannibals and their naive longing for the tasty flesh now taboo. These barbarous *frissons* were a regenerative force in his art.[67]

An exceptional picture, *Arii Matamoe (La Fin royale*; 18) illustrates this savage splendour and the cruelty in the distant age of the Areoi dynasty. Legend fired the painter's imagination. He wrote to Monfreid saying: " I think I'm on to a good thing ... I've just finished a severed head of a Kanak nicely arranged on a white cushion in a palace of my invention and guarded by women also of my invention. I believe it's a fair piece of painting. I can't say it's entirely mine since I stole it from a plank of pine. Don't tell anyone but, what can I say, one does what one can, and when the trees and the woods draw you a head it's really tempting to steal it."[68] This vision of decapitation in all its brutality and splendour takes us back to the decapitated heads of the martyrs and Redon's dreamlike apparitions of bodiless heads floating in space. One can also interpret the composition as a form of self-representation of the artist as pariah and martyr, living isolated in society. He is the superior being whose creation demands total self-sacrifice.

These supernatural apparitions, springing from branches, flowers and darkness, are formally close to Redon's phantasmagoria. They evoke the occult forces of Tahitian pantheism and the spirits of the dead lurking in the dark. His barbaric metaphors stem exclusively from what he terms his "his artistic centre".[69] He was affirming the autarchy of creation and, like Redon, could well have said, "I did an art all my own."[70] Yet his pictures, nurtured by the imagination and dreams, are nevertheless almost exclusively to do with colour, as in the works he admired by Delacroix and Van Gogh. His description of *Manao Tupapau* (12) confirms this: "To sum up – Musical part – Undulating horizontal lines – orangey and blue harmonies linked by their derivatives, yellows and violets. Lit by greenish sparks – Literary part – The spirit of a living woman joined to the spirit of the Dead."[71]

After two years of immersion in Polynesian culture, Gauguin returned to France with some fifty pictures, sculptures, innumerable drawings and

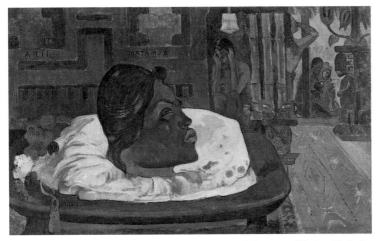

18 *Arii matamoe (The Royal End)*, 1892
Oil on canvas, The J. Paul Getty Museum, Los Angeles

manuscripts. On 4 June, 1893, he embarked the cruiser "Duchaffault", leaving Teha'amana weeping on the quayside.

CAHIER POUR ALINE

In December 1892, when he decided to return to France, Gauguin began writing a manuscript. The format of the notebook is the same as *Ancien culte mahorie*. It is not a continuous narrative but a succession of notes including passages from texts by Edgar Allan Poe and Richard Wagner, poems by Rimbaud, and a collection of thoughts and aphorisms. For the first time in his writings, Gauguin tell us some of his personal secrets. "I have known great misery," he wrote, "that is, to be hungry and cold and all this entails."

The composite cover is decorated on the outside with a strange creature evoking a tupapau. On the inside there is a reproduction of a picture by *Corot, Woman with a Mandolin*, and a watercolour of tropical fish. Like the text, composed of thoughts, analyses and political opinions, the *cahier's* iconography adheres to no preconceived scheme but freely associates forms and colours in a kind of journal. In a chapter entitled "The

genesis of a picture", Gauguin comments for the first time on *Manao Tupapau*, supplementing his explanation with a watercolour sketch sufficiently explicit to focus attention on the young woman's curvaceous buttocks.

After his return to France, Gauguin used the last pages of the exercise book to paste press articles about his exhibition at Galerie Durand-Ruel in November 1893, then dedicated the book to his daughter Aline, who had remained in Copenhagen with her mother and brothers: "Scattered notes, disjointed like Dreams, like life, made entirely of pieces."

NOA NOA

Gauguin began writing his Tahiti souvenirs only a few weeks before the opening of the exhibition at Galerie Durand-Ruel. He wrote the first draft in a simple and direct style on sheets of paper. The manuscript, only a few pages long, has no title and three cursory sketches as illustrations. It is now in the Getty Center for the History of Art and the Humanities, Malibu, California.

Realising that the text would not be finished for the exhibition opening, Gauguin succumbed to the lure of literary ambition, on the advice of a friend, the minor Symbolist writer Charles Morice. Together, they embarked on a book project, in which Morice was invited, as a literary professional, to dissertate on Gauguin's account of his time in Tahiti. The painter asked him for prose texts and poems in verse, and both worked in parallel. A year before he died Gauguin explained: "For me, there were *two aims* in this collaboration. It was not what other collaborations are, that is, two authors working together. The idea had occurred to me, in speaking about non-civilised people, to bring out their character alongside our own, and I thought it would be rather original to write (quite simply like a savage), and next to that have the *style* of a civilised man, which is what Morice is. So I *conceived* our collaboration and *arranged* it to that end; but also, since writing is not my line of work, as it were, to find out *which of the two of us*, the naive and rough-spoken savage or the man corrupted by civilisation, was the better."[72]

In the winter of 1893–94, Gauguin bought a large leather-bound album, in which he copied out his text, now entitled *Noa Noa* – "Fragrant" in Tahitian

– with the subtitle *Voyage à Tahiti*. The more elaborate style of this new version evokes the tone of accounts by navigator-discoverers of distant lands. Morice urged Gauguin to imitate Flaubert. To complement his description of his life on the island, seen through his pictures, Gauguin inserted a chapter on the Polynesian genesis and the sect of the Areois, copied from the *Ancien culte mahorie* manuscript, whose watercolour illustrations he also re-used with variations.

From the outset, *Noa Noa* was conceived as a book to be read and looked at, in which the images were as important as the words. In the winter of 1894, Gauguin produced a series of ten woodcuts intended to serve as chapter title pages.[73] But Morice was struggling to complete his bombastically-styled texts and doggerel verses and the book still was not finished when he decided to leave again for Tahiti. In June 1895, Gauguin departed for the South Seas for good with the album in his luggage, still hoping to receive Morice's reworked version of *Noa Noa*. It was not finished until 10 September, 1897[74] and its publication the following month in *La Revue blanche*, doubly infuriated Gauguin because he did not receive any royalties for it. The rift between the poet and the painter was now irreparable.

Gauguin immediately abandoned the idea of using the blank pages to copy out Morice's poems and began illustrating his manuscript instead. *Noa Noa*'s illustration is conceived as decoration, as an autonomous iconographic commentary justified solely by artistic concerns. It consists of quite long visual sequences in which drawings, photographs (19), prints, watercolours, wash drawings and tracings alternate with the pages of writing in no pre-determined or hierarchical order. He added the 1894 woodcuts, irregularly cut out with scissors as they were larger than the album pages. Some were heightened with watercolour after they had been pasted in. In a late text, Gauguin justified his fragmentary conception of the illustration as a kind of decorative automatic writing, "sketches of all kinds, flights of the pen, of the imagination; wild tendencies."[75]

In 1896–97, Gauguin complemented the *Noa Noa* album[76] with an illustrated manifesto of texts entitled *Diverses choses*. The cover's sophisticated decoration, produced at an unknown date, evokes the savage splendours and decorative abstractions of the artist's pictures and woodcuts. The album's epigraph is a phrase by Mallarmé heard at the 1893 exhibition: "It is extraordinary that one could put so much mystery into so much brilliance."

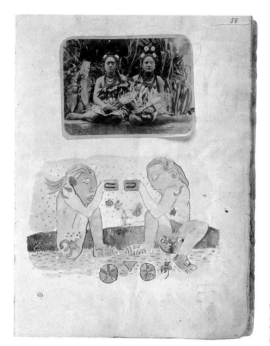

19 From the manuscript
Noa Noa, 1893–1897,
watercolour with photograph,
Musée du Louvre, Paris

The art historian **ISABELLE CAHN** *is a curator at the Musée d'Orsay, Paris. Her main area of focus lies on the second half of the 19th century and the beginning of the 20th century. She has organised a large number of exhibitions on a variety of artists and art movements. She is the author of monographs on numerous French Impressionists and publications on Impressionism in general.*

Author's note: The author would like to express her heartfelt gratitude to Olivier Morel, without whom the invitation to this voyage would not have been possible.

1 Georges-Albert Auruier, "Le symbolisme en peinture", in: *Mercure de France*, no. 15, March 1891 pp. 155–65.
2 On 23 February, 1891, Gauguin auctioned the contents of his studio at the Hôtel Drouot, raising 9,635 francs for 29 pictures sold.
3 "… You seem to me to be fortified by other people's hate, your personality delights in the antipathy it arouses, intent on remaining intact." Letter to Gauguin from Strindberg, published as the introduction to the catalogue of the auction at the Hôtel Drouot, 18 February, 1895.
4 Gauguin to Theo van Gogh, November 1889.
5 Henri Mondor, *Stéphane Mallarmé: Correspondance*, 11 vols., Paris, 1959–85, 1973, p. 211 no. 3.
6 Françoise Cachin, *Gauguin*, Paris 1968, 1989, pp. 113–35.
7 Victor Segalen "Hommage à Gauguin", in: *Lettres de Paul Gauguin à Georges-Daniel de Monfreid*, Paris 1950, p. XVII.
8 Gauguin to Mette, 4 June, 1891, in: *Lettres de Gauguin à sa femme et à ses amis*, compiled, annotated and prefaced by Maurice Malingue, Paris 1946, no. CXXV, pp. 216–17.
9 *Noa Noa*, Musée d'Orsay manuscript.
10 "The Tahitian soil is becoming completely French and little by little the old order will disappear. Our missionaries had already introduced a good deal of Protestant hypocrisy and wiped out some of the poetry, not to mention the pox that has attacked the whole race …", Gauguin to Mette, June 1891 – dated July by Malingue, in Malingue, no. CXXVI, p. 219.
11 Gauguin to Daniel de Monfreid, 7 November, 1891, no. II, in: *Lettres*, 1950, pp. 2–3.
12 Gauguin to Daniel de Monfreid, 11 March, 1892, no. III, in: *Lettres*, 1950, p. 6.
13 *Noa Noa*, first manuscript written by Gauguin in 1893, Getty Center for History of Art and Humanities, Malibu. This manuscript was transcribed by Jean Loize, *'Noa Noa' par Paul Gauguin*, Paris 1966, passage cited pp. 24–25.
14 Gauguin took reproductions of artworks with him to Tahiti, including a photograph of a frieze of a banquet from an Egyptian mural at Thebes dating from the 18th dynasty.
15 "The women, for want of beauty proper," Gauguin wrote to Mette, "have something penetrating, infinitely mysterious about them", letter to Mette, June 1892, Malingue 1946, no. CXXIX, p. 227.
16 The first picture is in the Worcester Art Museum (W 440), the second in the Nelson-Atkins Museum of Art, Kansas City (W 424).
17 In a letter to Mette, dated 4 June, 1891 by Malingue, Gauguin noted: "Always this silence. I understand why these people can remain seated for hours, days at a time, without saying a word, gazing sadly at the sky", Malingue 1946, no. CXXV, p. 218.
18 Letter to Mette, 8 December, 1892, Malingue no. CXXXIV, p. 236.
19 The Catholic and Protestant missionaries demanded that women wear loosely fitting, long-sleeved robes concealing the body's forms.
20 Traditional Polynesian bamboo or wooden house with a pandanus leaf roof.
21 Letter to Mette Gauguin, June 1892, Malingue 1946, no. CXXIX, p. 227.
22 Letter to Mette, April 1892?, dated July by Malingue, Malingue 1946, no. CXXX, pp. 229–30.
23 "How I wish I had your memory to learn the language quickly as very few people speak French here", letter to Mette, July 1891, Malingue no. CXXVI, p. 219.
24 Letter no. III, 11 March, 1892, p. 6.
25 *Le Mariage de Loti* was published in 1880.
26 Shortly after his return to Paris, Gauguin organised an exhibition of his work at Galerie Durand-Ruel.
27 Preface of the catalogue of the Gauguin auction at the Hôtel Drouot on 18 February, 1895, dated 1 February, 1895.
28 Letter to Strindberg, 5 February, 1895, Malingue 1946, no. CLIV, p. 263.
29 The large red-skinned bananas that were the staple food.
30 Gustave Geffroy, "Retour de Tahiti" in *L'Echo de Paris*, 14 November, 1893. Gauguin pasted this article into *Cahier pour Aline*.
31 Lettre to Paul Sérusier, 25 March, 1892, in: idem, *ABC de la peinture. Correspondance*, Paris 1950, p. 60.
32 The first text Gauguin wrote after he returned to Tahiti (November–December 1893), to explain his stay and his Tahitian pictures. The manuscript is now in the Getty Center for History of Art and the Humanities, Malibu.

33 "The linear and progressive vision of man's evolution is associated with an hierarchical classification of human races, from the most to the least ancient, from the least to the most civilised", Marylène Patou-Mathis, *Le Sauvage et le Préhistorique, miroir de l'homme occidental*, Paris 2011.

34 Gauguin to Monfreid, 11 March, 1892.

35 The Tahitian title written on the canvas, *Ia Orana Maria*, means "Je vous salue Marie". The picture, painted *c*. 1891–92, is in the Metropolitan Museum, New York.

36 *Noa Noa*, Musée d'Orsay manuscript, chapter VIII, p. 129 ff.

37 "I am completing Tehura's lesson with the aid of documents found in an album by Moerenhout, a former consul. Monsieur Goupil, a colonial in Tahiti, obligingly allowed me to read it", *Noa Noa*, Musée d'Orsay manuscript, p. 131.

38 In the spring of 1892, Gauguin drew a plan for a *marae* on a page of the *Ancien culte mahorie* manuscript.

39 Dario Gamboli, "Où est le *marae*?", in: *La Revue du Musée d'Orsay*, no. 20, spring 2005, p. 9.

40 A hill that Dario Gambomi compared to Rano-Raraku on Easter Island, famous for its monolithic statues.

41 Statue depicting ancestors.

42 "The images of the Tiis were placed at the farthest ends of the *maraës* (temples) and formed the limit which circumscribed the sacred places", *Noa Noa*, Musée d'Orsay manuscript, p. 146.

43 The *Frie Udstilling*, with a room entirely for Gauguin and Van Gogh, opened on 26 March, 1893. In a letter prior to his delivery, Gauguin added after *Parahi Te Maraè*: "There is the Maraè (temple of prayers and human sacrifices)", letter to Monfreid, 8 December, 1892, no. VII, p. 16.

44 *Noa Noa*, Musée d'Orsay manuscript, p. 17.

45 A few months later, Gauguin suggested to Morice that he reproduce *Parahi te marae* as a backdrop for one of his ballets, for a scene with Salome. Letter to Morice, Paris, Musée du Louvre, Archives des musées de France.

46 Dieu, creator of the universe.

47 Folio 22.

48 *Noa Noa*, Musée d'Orsay manuscript, p. 17.

49 He asked his wife not to sell the picture at the Copenhagen exhibition for less than 2,000 francs, whereas he was asking 700 francs for *Parahi Te Marae*. "I would keep back the latter for later on," he added, letter to Mette, 8 December, 1892, in Malingue no. CXXXIV, p. 237.

50 *Noa Noa* and *Cahier pour Aline*.

51 *Noa Noa*, Musée d'Orsay manuscript, pp. 109–10.

52 Jehanne Teilhet-Fisk, *Paradise reviewed: an interpretation of Gauguin's Polynesian symbolism*, Ann Arbor 1983, p. 88.

53 Wooden tablet covered with glyphs.

54 *Noa Noa*, Musée d'Orsay manuscript, pp. 103–04.

55 Gauguin greatly admired Puvis de Chavannes. He had a reproduction of *Hope* in his hut which he later included in one of his still lifes.

56 *Noa Noa*, Musée d'Orsay manuscript.

57 Letter to Monfreid, April–May (?) 1893, in: *Lettres*, no. XII p. 28.

58 Letter to Monfreid, 31 March, 1893 [redated October 1892 by Richard S. Field, *Paul Gauguin: the paintings of the first trip to Tahiti*, Cambridge 1963, 1977, p. 364, in: Lettres 1950, no. XI, p. 24.

59 Gauguin had photographs of bas-relief friezes in the temples at Borobudur (Java).

60 Tahitian name designating the *tikis*, wooden statuettes representing a deity or spirit of an ancestor.

61 The first exhibition of Gauguin's sculpture was organised at the Musée du Luxembourg à Paris in 1927.

62 Letter to Monfreid, 31 March, 1893 [redated October 1892 by Richard S. Field, *Paul Gauguin: the paintings of the first trip to Tahiti*, Cambridge 1963, 1977, p. 364, in: Lettres 1950, no. XI, p. 24.

63 Tahitian choirs.

64 *Noa Noa*, Getty manuscript.

65 *Noa Noa*, Musée d'Orsay manuscript, pp. 46–48.

66 Tahitian erotic dance involving rhythmically swaying the hips and belly.

67 "I am leaving to find some peace," he declared as he left Paris, "to rid myself of the influence of civilisation. I want to do only simple, very simple art: to do this I need to reimmerse myself in wild nature, to see only savages, to live their life with the sole concern of rendering, like a child would, the conceptions of my brain, aided solely by the means of primitive art, the only good, the

only true ones." Jules Huret, "Paul Gauguin devant ses tableaux", in: *L'Echo de Paris*, 23 February, 1891.

68 Letter to Monfreid, June 1892, in: *Lettres* 1950, no. V, pp. 10–11.

69 "My artistic centre is in my brain and not elsewhere and I am strong because I am never sidetracked by others and do what is in me", letter to Mette, March 1892, Malingue no. CXXVII, p. 221.

70 *A soi-même*, Dario Gamboni, *La Plume et le Pinceau*. Odilon Redon, Paris 1989, p. 28.

71 "Genèse d'un tableau", in: *Cahier pour Aline*, Paris, Bibliothèque de l'INHA; facsimile published by Damiron, Paris, 1963.

72 Letter to Monfreid, May 1902, in: *Lettres*, no. LXXIX, p. 192.

73 Barbara Stern Shapiro, "Des formes et des harmonies d'un autre monde", in: *Gauguin Tahiti, l'atelier des tropiques*, 2003, p. 166.

74 The manuscript is in the Temple University Library, Philadelphia.

75 *Avant et Après*, 1903.

76 The Musée d'Orsay manuscript is kept in the Louvre's Department of Prints and Drawings.

PAUL GAUGUIN'S WORK – AVANT-GARDE OR ZEITGEIST?

Eckhard Hollmann

If we attempt to understand Paul Gauguin the artist and develop an understanding for what this "savage" has contributed to the history of painting, then a few questions automatically rear their heads. What did Gauguin want to achieve for himself as an artist? How did his fellow artists see him, and how did they judge his artistic activities? And finally: which of his expectations and ideas was he able to implement and how should we judge this from our present perspective?

Gauguin was definitely one of those visual artists who never ceased to shed philosophical and literary light on their artistic work. Like Kandinsky after him, who sought to capture the "spiritual" in painting, Gauguin did not merely want to develop a compelling new personal style, he wanted nothing less than to develop a comprehensive theory of art, at the core of which his own works were to stand.

When he left his job at the Thomereau insurance agency in 1883, Gauguin was determined to leave his bourgeois life behind and to focus wholly and completely on painting. He was adamant that he would be able to support his family as an artist and live in style. When he was no longer able to ignore the realisation that he would not succeed in this aim, he took no serious steps to return to a bourgeois life and a steady job. Instead, he

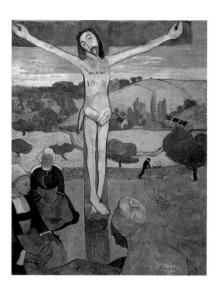

naively clung to the hope of finding paradise on Earth *somewhere*: "The day will come, and it will come soon, when I will hide in the forests of the South Sea islands and live a life of delight and tranquillity dedicated to my art."[1] He became so engrossed in the mission of becoming a great artist, a mission he felt very deeply, that he was willing to destroy his own family for it, and accept an uncomfortable and at times wretched life before suffering a miserable death in his self-imposed exile. This gradual and consistent distancing of himself from Europe increasingly alienated him from his artist friends and European artistic developments in general. Although it was quite different from how he had imagined it – during all his years in the South Seas he never stopped dreaming of a triumphant return to Paris – this life of a hermit allowed him to develop his painting completely unimpeded and largely uninfluenced by contemporary trends. After he had left Paris a second time in 1895 to return to his South Sea refuge forever, he was no longer interested in what was being discussed by artists and intellectuals in Paris. When he wrote letters to Europe now – whether to Charles Morice, Emile Schuffenecker or Daniel de Monfreid – they were either about the interpretation of his own works or about money, canvas, paints, or his survival. His solitude alone fuelled his theoretical occupation with art and honed his philosophical thinking.

But let us return to the starting point of his artistic activities. He initially felt close to the Impressionists (21). However, he only appreciated their relaxed painting style; he felt their motifs were too trivial and their formal language not expressive enough. So Vincent van Gogh's invitation in 1888 to come and live and paint with him in Arles came at just the right time. The encounter led to an extremely intense relationship, but it soon became clear that their artistic views and intentions were as divergent as their lifestyles. "Between the two natures, his and mine, the one wholly volcanic, the other equally boiling hot, a kind of fight seemed to be brewing."[2] Although they both benefited artistically from this year together, the price they paid was their falling out for good.

Before Gauguin went to Brittany in May 1890, he had already produced masterpieces such as *The Yellow Christ* (20), *Portrait of the Artist with the Yellow Christ* (22), *The Green Christ* (23) and *Beautiful Angela* (24). As a result of much work and a tireless intellectual and artistic confrontation with his painter friends, and thanks to inspiration from foreign cultures,

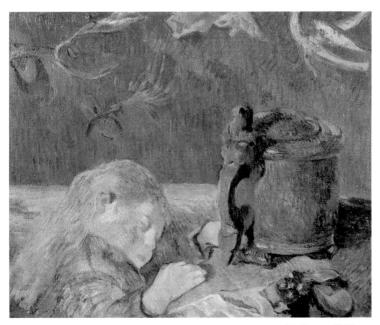

21 *The Sleeping Child*, 1884
Oil on canvas, Collection Josefowitz, Lausanne

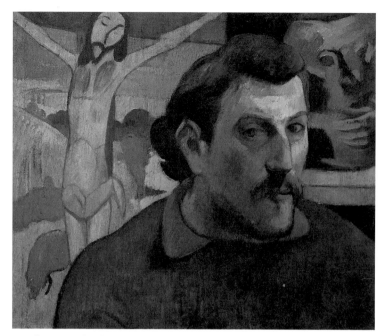

22 *Self-Portrait with Yellow Christ*, 1889
Oil on canvas, Musée d'Orsay, Paris

his travels, the beauty and harshness of the Breton landscape and the deep religiosity of its inhabitants, he found the personal style he had sought for so long.

The colourfulness increased, the figures and objects are surrounded by dark lines. The shapes, too, gained in expression and tension. The figures push beyond the picture frame; there is tension, too, between the individual colour fields and shapes. The perspective, the atmosphere, the subtleties and colour nuances of a landscape captured so outstandingly by the Impressionists, no longer mattered. What Gauguin cared about was expressing his own mental state: his feelings as well as his understanding of the world.

His new way of painting was greeted with enthusiasm by the Symbolist poets, particularly Paul Verlaine, Charles Morice, Albert Aurier and Octave Mirbeau. They believed it to be a direct visual reflection of their own ideas.

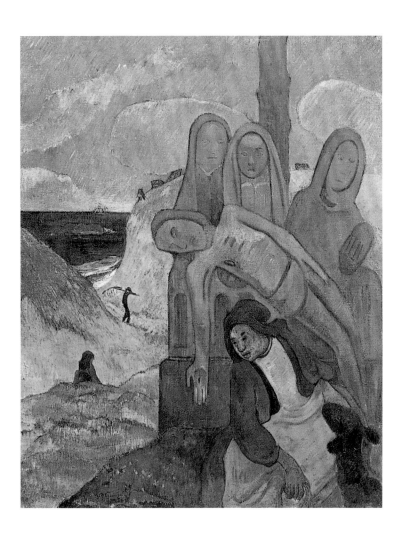

23 *The Green Christ (Breton Calvary)*, 1889
Oil on canvas, Musées Royaux des Beaux-Arts de Belgique, Brussels

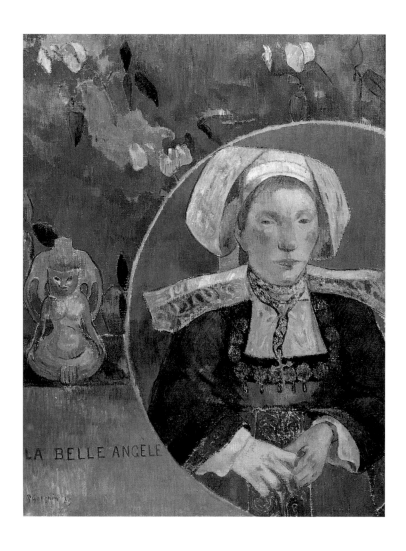

24 *Beautiful Angela*, 1889
Oil on canvas, Musée d'Orsay, Paris

Camille Pissarro on the other hand, who believed art had to be "absolutely social, anti-authoritarian and anti-mystical"[3], angrily denounced Gauguin as a charlatan, while young artists like Émile Bernard, Paul Sérusier and the Nabis made him their role model. That was more or less the state of things when Gauguin set off for Polynesia in 1891.

WHERE DO WE COME FROM? WHAT ARE WE? WHERE ARE WE GOING?

Just six years later the letters and writings in which Gauguin reflected on his own end were on the increase. In addition he embarked on a large work, almost four metres wide, that he painted straight on to the canvas without any preparatory drawing (25). "I have painted a philosophical work on this subject that is comparable to the Gospels. I believe it was successful," he later wrote in a letter to Daniel de Monfreid. He further reported to his friend: "The two upper corners are chrome yellow with an inscription on the left and my signature on the right, as if it were a fresco painted on a gold base and damaged at the corners."[4]

Gauguin therefore associated a double claim with this large work: artistically he placed it in the field of fresco painting, while he considered its contents to be a "philosophical work". The painting is to be "read" from right to left. His compositional framework consists of three groups of people: on the right three women and a child represent birth and childhood. In the middle a woman is picking an apple. Here Gauguin is referring to the biblical story of the loss of Paradise. Eve picks the apple from the Tree of Knowledge, which reveals to her the nature of love, but at the same time plunges her into eternal sin. Seated on the left-hand side of the painting is an old woman as a symbol of death.

The palette feels reduced and is largely composed of the contrasting pairs orange-blue and red-green. In this way the painting is given a monumentalism completely independent of its actual dimensions, and this is achieved solely through artistic means. This painting could definitely pass as a "fresco".

The figures depicted barely relate to each other, nor to the idol in the left third of the painting, which embodies divinity in the broadest sense. Instead they are embedded in the surrounding landscape: they are part of

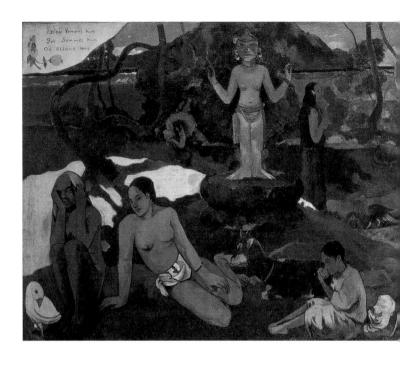

nature, of the creation they belong to, from which they have come and to which they will return, regardless of their actions, their mutual relationships, or any religious ties. It is an image of earthly existence, advocating the "joie de vivre" that we should embrace as much as possible before social pressures or simply the biological ageing process rips one pleasure from us after another. This simple message dominates all of the painter's works. In this example he evokes it in a successful combination of classical composition and his own avant-garde pictorial inventiveness.

25 *Where do we come from? Who are we? Where are we going?*, 1897
Oil on canvas, Museum of Fine Arts, Boston

WHAT REMAINS?

Like every artist, Gauguin always carried his "imaginary museum" around
with him in his head, using it for his own iconography. It is crucial that he
subordinated all of these reference images and memories to his creative
will, that he managed to integrate them into a personal style of great cohe-
sion but also subtle differentiation. He himself recognised this, and confi-
dently stated in a letter to Paul Sérusier: "The core of my art lies in my
head and nowhere else: I am strong because I do not let myself be dis-
tracted by anything and because I follow what is in me. Beethoven was
deaf, he was cut off from everything; that is why his works have the great-
ness of an artist who lived on his own planet."[5]
Gauguin often incorporated motifs and figures from contemporary
painters in his compositions; however, he naturally also subjected them
to his independent and original expressive powers – Gustave Courbet's

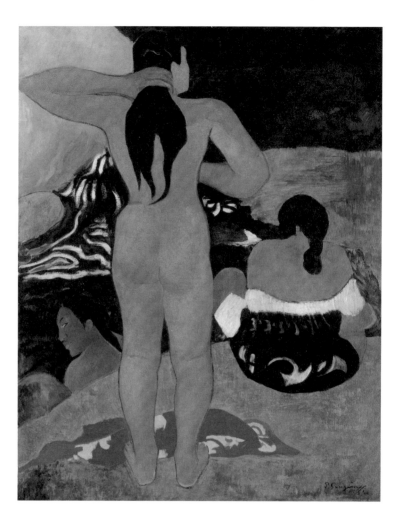

26 *Tahitian Women on the Beach*, 1892
Oil on canvas, The Metropolitan Museum of Art, New York

27 Gustave Courbet, *The Spring*, 1868, oil on canvas, The Metropolitan Museum of Art, New York

28 Karl Schmidt-Rottluff, *Dusk*, 1912 Private collection

The Spring (27) makes a return in *The Tahitian Women on the Beach* (26) from 1892.

Another aspect for which Gauguin deserves credit is that he restored to painting its literary element, which had been banned by the Impressionists. Without ever falling into the anecdotal-incidental he "narrated" his views and his stories and conveyed his wishes and ideas and ultimately his world view, using only the visual artistic means developed by him. This world view was the desired reconciliation between civilisation and nature, between culture and "primitiveness". He was never able to dispense formally with European iconography; he never forged onwards into true "primitiveness" in the way the German Expressionists did, for example, a few years later. The members of the artists' group Die Brücke from Dresden were familiar with African tribal art only from museums; nevertheless this encounter sufficed for an extraordinary break with tradition (28). Gauguin, who spent many years living among the "savages", never engaged in the destruction of forms; he only ever painted his illusion of the idyllic primitive state, using artistic means that were almost classical (29). He was equally matter-of-fact in the way he used both old and contemporary art as inspiration for his pictorial invention, as he also occasionally did with photographs. Nevertheless his paintings were generally perceived as a

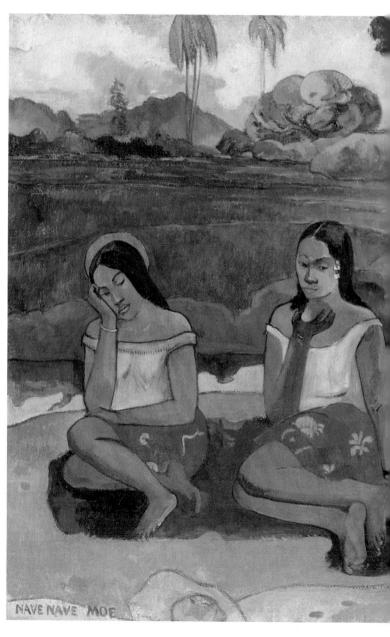

29 *Nave nave moe (Sacred Spring/Sweet Dreams)*, 1894
Oil on canvas, Hermitage, St. Petersburg

provocation at the time. All the aspects of his painting that were to become significant for the twentieth century were met with rejection by contemporary critics and audiences: the abandonment of correct perspective, excessive colourfulness, the black outlines ("Cloisonnism"), the use of local colours, the formal reduction, the strong rhythmic nature of the composition of his paintings, and, not least, the "lewd" manner of his depictions. Edvard Munch was the first to develop Gauguin's woodcut-art further; Art Nouveau adopted the decorative, ornamental traits of his works; Henri Matisse was excited by the colourfulness and rhythm of Gauguin's pictures; and the paintings of the German Expressionists would have been unthinkable without him. It is immaterial whether individual painters stand by Gauguin's works or reject them – the influence of his art on the development of Modernism is uncontested, and remained evident until the very recent past. Many of the "Junge Wilde" of the eighties identified with Gauguin's protest stance and his unconventional views. Today Gauguin's paintings are crowd pullers for many important collections all around the world and the international art audience celebrates the romantic outsider of early Modernism as one of the true greats of art history.

ECKHARD HOLLMANN *studied art history and history at Leipzig University. He has produced several publications on Modern Art and on contemporary art in Germany as well as on Paul Gauguin and his time. Eckhard Hollmann lives in Munich and works as a freelance author and editor.*

1 Pola Gauguin, *Mein Vater Paul Gauguin*, Berlin 1951, p. 122.
2 Eckhard Hollmann, *Paul Gauguin, Bilder aus der Südsee*, Munich 1996, p. 8.
3 Michael Hoog, *Paul Gauguin*, Munich 1987, p. 80.
4 Kuno Mittelstädt, *Paul Gauguin – Briefe*, Berlin 1962, p. 95.
5 Henri Perruchot, *Paul Gauguin*, Munich 1991, p. 267.

BIOGRAPHY

Paul Gauguin
1848–1903

1848 Eugène Henri Paul Gauguin is born in Paris on 7 June. His father Clovis works as a journalist for the republican newspaper *Le National*; his mother Aline Marie is the daughter of the painter André François and the writer Flora Tristan, a Spanish woman with Peruvian roots. Paul has an elder sister, Marie.

1849 The February Revolution causes the Gauguin family to leave France and emigrate to Peru. The father dies of a heart attack during the crossing.

1849–1855 Aline and the two children are taken in by the wealthy great-uncle Don Pio Tristan Moscoso in Lima.

1855 The family returns to France.

1856–1862 Since the mother has to secure a living, Paul attends the Petit Seminaire de la Chapelle-St.-Mesmin boarding school near Orléans as a day student.

1862 The family moves to Paris, where Aline runs a dressmaker's shop. Paul attends the *lycée* in Paris.

1865–1867 The 17-year-old Paul Gauguin joins the merchant navy as a cabin boy. While he is away at sea, his mother dies in St.-Cloud on 7 July 1867. She makes a family friend, the art collector Gustave Arosa, Paul's guardian in her will.

1868–1870 Gauguin enters the navy as a sailor and participates in the Franco-Prussian War.

1871 After the end of the war Gauguin leaves the navy. Thanks to Gustave Arosa's connections he finds employment at the Bertin Bank in Paris, where he embarks on a career as an investment consultant. He draws and paints in his free time.

1872 Gauguin attends the free Académie Colarossi with his colleague Emile Schuffenecker. Arosa introduces him to Impressionism.

1873 Gauguin marries Mette-Sophie Gad from Denmark on 22 November; she has been working as a nanny in Paris.

1874 Their son Emile is born. Gauguin meets the painter Camille Pissarro.

1876–1879 His painting *Under the Trees at Viroflay* is hung in the official Salon d'Automne. Gauguin rents his own studio in Montparnasse. In 1877, Aline, the only daughter from the marriage with Mette, is born.

1879 Gauguin participates in the Fourth Impressionist Exhibition with a sculpture. Son Clovis is born. Gauguin continues to speculate successfully on the stock exchange and invests the money, for example, in works by Camille Pissarro, Édouard Manet, Paul Cézanne, Auguste Renoir, Claude Monet, Alfred Sisley and Johan Jongkind. In the summer he paints together with Pissarro in Pontoise.

1880–1882 Gauguin works in the Thomereau insurance agency. He participates in the Fifth, Sixth and Seventh Impressionist Exhibitions. His son Jean René is born in 1881. Gauguin spends the summer holidays painting with Pissarro in Pontoise, where he also meets Cézanne.

1883 He gives up his job with Thomereau, believing he can feed his family with his painting. The couple's fifth child, son Pola, is born.

1884 The family moves to Rouen, where Gauguin hopes to sell his paintings. The family's financial situation deteriorates rapidly. At Mette's insistence they move to her parents in Copenhagen. Gauguin finds work there as an agent for canvas manufacturer Dillies & Co.

1885 Gauguin's first exhibition in Copenhagen closes after a few days. He is also unsuccessful as a sales representative too. He falls out with his parents-in-law and returns to Paris with his six-year-old son Clovis.

1886 Gauguin participates in the Eighth (and last) Impressionist Exhibition with 19 paintings. He sends Clovis to boarding school and moves to Pont-Aven in Brittany. Here he makes the acquaintance of the painter Émile Bernard and the potter Ernest Chaplet, whose "apprentice" he

becomes. He returns to Paris in November, where he meets the brothers Vincent and Theo van Gogh, and Edgar Degas.

1887 Clovis returns to Denmark. Gauguin and his painter friend Charles Laval sail to Panama and Martinique. Gauguin is fascinated by the tropical landscape; after his return van Gogh is thrilled by his paintings. At Schuffenecker's he meets the painter Daniel de Monfreid, who will become his lifelong friend.

1888 Gauguin stays in Pont-Aven between February and October to work with Laval, Paul Sérusier and Bernard. He turns away from Impressionism to develop a new style, Synthetism, and paints Vision *After the Sermon*. He spends the late autumn with van Gogh in Arles in order to work with him. After a serious, not to say physically violent confrontation he returns to Paris on 23 December.

1889/90 Gauguin travels to Brittany to paint. Together with friends he paints Marie Henry's guesthouse in Le Pouldu. He exhibits 17 paintings in the Café Voltini immediately next to the grounds of the Paris World Fair. Vincent van Gogh dies on 29 July.

1891 Gauguin decides to travel to the tropics. The profits from auctioning off 29 paintings in the Hôtel Drouot allow him to sail to the South Seas. In spring he goes to Copenhagen to say goodbye to his family. On 1 April he embarks in Marseille, bound for Pateete in Tahiti, where he arrives on 9 June. While there he lives with Teha'amana, a young woman, and starts Noa Noa, his travel journal about Tahiti.

1892 In spring Gauguin suffers a severe heart attack and has to be hospitalised. His financial woes are so dramatic that he is barely able to live and cannot afford painting materials. The profit from the sales of his paintings is not passed on to him. He learns that Theo van Gogh has died.

1893 Completely penniless, Gauguin obtains a free passage to France from the government and arrives in Marseille on 30 August. A small inheritance from his uncle Isidore allows him to rent a flat in Paris where he lives with Annah, a woman from Java. His hope of achieving recognition

30 The children of the marriage to Mette

31 Paul and Mette Gauguin in Copenhagen, 1885

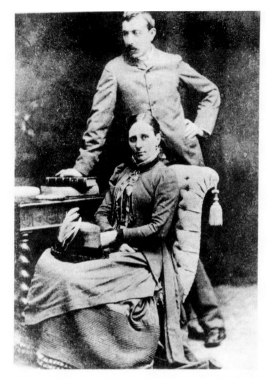

Paul Gauguin photographié avec ses enfants Émile et Aline, pendant son séjour à Copenhague.

32 Paul Gauguin with his children Émile and Aline in Copenhagen, 1891

33 Gustave Arosa

with his new paintings from Tahiti fails. His exhibition with the well-known art dealer Henri Durand-Ruel is also unsuccessful. Together with Charles Morice, Gauguin starts preparing *Noa Noa* for publication.

1894 Between April and December Gauguin spends most of his time in Brittany. A broken ankle sustained during a fight with sailors in the harbour of Concarneau forces him to spend two months in hospital. Back in Paris he learns that Annah has cleared out his studio apart from his paintings, and has disappeared.

1895 After the failure of the second auction of his paintings in the Hôtel Drouot Gauguin leaves Marseille for Tahiti again on 3 July. Upon arrival he continues working on Noa Noa.

1896 He lives with a young girl called Pau'ura. They have a daughter together who dies shortly after birth. Gauguin has to be hospitalised again, this time in order to have his syphilis treated.

1897 Morice publishes *Noa Noa* in the *Revue Blanche* in Paris. Gauguin's daughter Aline dies of pneumonia. He writes his last letter to Mette, with whom he has continued an active correspondence. His health deteriorates again. He creates *Where Do We Come From? What Are We? Where Are We Going?*

1898 Gauguin tries to take his life with arsenic and is admitted to hospital. In order to earn money he takes a job as draughtsman with the land registry in Papeete. Gauguin founds the satirical monthly publication *Le Sourire* in which he supports the concerns of the Maori. As a result, he comes into conflict with the colonial administration. The Parisian art dealer Ambroise Vollard buys nine paintings from Gauguin and organises an exhibition.

1899 Pau'ura has a son with Gauguin, called Emile.

1900 Thanks to a contract with Vollard that secures him a small, steady income, Gauguin's financial situation improves. His son Clovis dies.

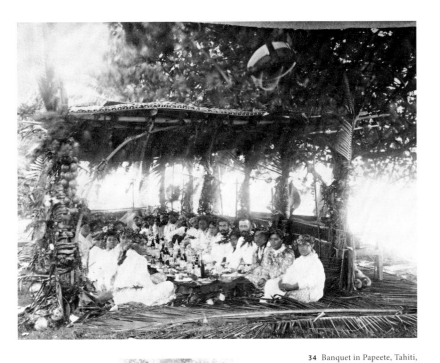

34 Banquet in Papeete, Tahiti,
July 19, 1896

35 Paul Gauguin's
house in Paea, 1896

36 Paul Gauguin in Papeete,
Tahiti, July 19, 1896, detail

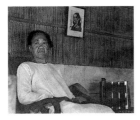

37 Pau'ura aged 55 (b. 1882), 1937

1901 Gauguin once again spends time in hospital at the start of the year. In September he moves to Hiva Oa in the Marquesas Islands, around 1,000 kilometres east of Tahiti. He sets up his *Maison du jouir* here. There are renewed conflicts between Gauguin and the colonial administration. He paints very little and becomes increasingly addicted to alcohol.

1902 His friend Monfreid advises him against his planned return to France, since his "mythical status" would suffer as a result.

1903 The conflict with the colonial administration escalates. Gauguin is sentenced to a fine and three months in prison for defamation. On 8 May, before starting his sentence, he dies alone in a hut in Atuona, his home since 1901. He is buried at the Catholic cemetery in Hiva Oa on 9 May.

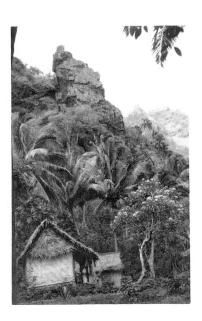

38 Paul Gauguin's house on Hiva Oa, 1903

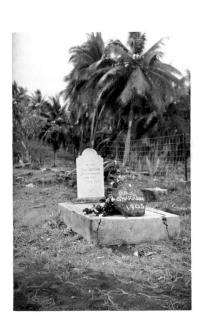

39 Gauguin's favourite path in Atuona on Hiva Oa, 1937

40 Paul Gauguin's grave on Hiva Oa, 1937

Paul Gauguin, photographed by Boutet de Monvel in Paris,
shortly before his departure for Tahiti, 1891

ARCHIVE

Discoveries, Letters, Documents
1888–1922

In December 1888 Paul Gauguin reported to Émile Bernard on his visit to Vincent van Gogh in Arles. Shortly afterwards, following the escalation of a quarrel between the two painters, Gauguin left Arles for Paris.

Dear Bernard!

Thank you for your letter and for getting the paints for me. You don't say whether Tanguy[1] regards the picture that you gave him as sufficient compensation. In any case the supplies I've received have to be paid for in cash, the necessary money is with van Gogh and is at your disposal. Was it not possible for you to dispatch a frame for a picture size 50? […] I feel altogether out of place in Arles, everything is so cramped, so poor, neither the landscape nor the people appeal to me. Vincent and I generally agree on very little, especially on our views about painting. He admires Daumier, Daubigny, Ziem and the great Rousseau, all of them people I can't stand. On the other hand he looks down on Ingres, Raphael, Degas, all people I admire. I just say "You're right, master" simply for the sake of peace and quiet. He likes my pictures very much, but when I'm at work, he always finds something that I'm not doing right. He is a Romantic, while I prefer the Primitives. As far as paint is concerned, he sees happiness in a thick application, such as you find with Monticelli, but me, I hate this hotch-potch in technique […]

Loving handshake. Kind regards from Vincent; he asks me to thank you for the study that you sent him in exchange.

Paul Gauguin

1 Small art and art-supplies dealer, known as Père Tanguy.

I Vincent van Gogh, *Painting Sunflowers*, 1888, oil on canvas, Stedelijk Museum, Amsterdam

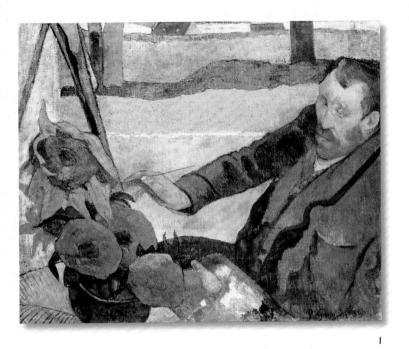

2

On 24 March 1891, shortly before he set off on his first trip to Tahiti, Paul Gauguin wrote this euphoric-sounding letter to his wife Mette. The two were never to see each other again.

My adored Mette!

Adoration that is often enough full of bitterness. [...] I know how difficult it is for you at present, but look, we're heading towards a secure future, and I will be happy – very happy – if you are prepared to share it with me.

The time will come when, freed from our passions, with white hair, we shall enter upon an era of peace and spiritual happiness, surrounded by our children, flesh of our flesh. I have told you only too often: your family are acting wrongly by getting you worked up against me, and one thing is clear: I want nothing to do with them.

Yesterday there was a dinner in my honour, at which forty-five people – painters and writers – were present, with Mallarmé presiding. Verses,

toasts and the warmest homage to me! I assure you, in the coming three years I will fight a battle which will allow us – you and me – to live safe from all problems and inconveniences. You will rest, and I shall work.
[…] Farewell, dear Mette, dear children. Keep loving me. And when I return, we will remarry. The kiss that I send today is, therefore, an engagement kiss.
Your Paul

3

On 18 May 1892 Maître Goupil, notary in Papeete, confirmed in his own hand to Paul Gauguin the receipt of 36.75 francs for the safekeeping of various items.

4

"Can you please buy and send me [...]" – Paul Gauguin often ordered brushes, paints and canvas from his friend Daniel de Monfreid in Paris, as in this letter of January 1900. He also allowed Monfreid to pay for the purchases, for Gauguin only rarely had any money.

[...] The last batch of Lefrancs paints that you sent me are dreadful. The ultramarine and lake turn thick and become pitch-like and gelatinous, the Veronese green [viridian] has white in it, which is very ugly when it dries, as the white comes to the surface. If R... comes to an agreement with you, I would ask you to send the following paints (**good paints**) in two or three packages:

25 tubes white	3 cadmium no. 2
10 ultramarine	4 emerald green
5 Prussian blue	20 Veronese green, good quality
5 cobalt	5 terre verte
5 chrome yellow	5 pale cinnabar
10 yellow ochre	3 rose madder (not pink)
5 ocre ru	3 carmine lake
3 cadmium dark	

If possible, grind five tubes of "bleu charron" for me and five tubes of minium (**not** "mine orange").
If possible, please buy me the two-metre-broad canvas (thick and a bit velvety – the bumps don't bother me, they can be cut down), and please have them prepared with a little glue and very little Spanish white, no "terre de pipe". Properly smooth. Otherwise I'll have to take coarse canvas, such as Puvis de Chavannes, with as thin a layer as possible, but that is **expensive, expensive!!**

3 Written in Paul Gauguin's own hand, 1892

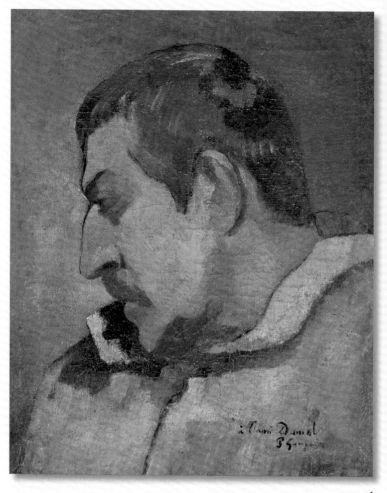

4

5

In 1901 Paul Gauguin moved to the island of Hiva Oa, some 1,000 kilometres from Tahiti. Here he began writing his memoirs under the title Avant et après. *He died on 8 May 1903, six weeks after completing the manuscript.*

[…] A critic who visits me looks at the pictures and asks, all uptight, to see my drawings. My drawings! Never! They are my letters, my secrets. The public man, the private man.

You want to know who I am. Aren't my works enough? Even now, as I write, I only show what I want to show. But sometimes you see me quite naked, that's no argument. One has to see the inside. And quite apart from that I do not always see myself very clearly.

[…] Probably the critic meant it that way when he asked about my drawings and said to himself as he did so: "Let's see if he can draw." He needn't worry. I'll enlighten him. I have never been able to do a proper drawing, I've never been able to handle a *tortillon* or a bread dumpling. There's always something missing: **colour**.

5

4 *Self-Portrait* for his friend Daniel (de Monfreid), 1896, oil on canvas, Musée d'Orsay, Paris

5 Drawing from *Avant et après*, 1901/03

6

*On 25 September 1903, Mette Gauguin wrote to Daniel de Monfreid, who had
told her of the death of her husband.*

Dear Sir,

in response to your letter of 12 September, I must first thank you for the
condolences which you expressed when telling us of the death of the father
of my children, news which caused me all the more pain in that I can only
presume that my poor Paul died in particularly sad circumstances. On my
last trip to Paris a year ago, my friend Schuffenecker told me that Paul was
ill and unhappy, but I hadn't thought that the end was so near.

I know that you have been seeing to Paul's affairs for years, and I would be
most grateful if out of affection for the departed would continue to do so!
[...] As I have had no direct news from Paul whatever for the past ten
years, I have not the slightest idea of the state of his affairs or of what he
may have bequeathed to our three sons and me. Perhaps Schuffenecker has
told you that I have been working for 19 years in order to bring up my
children, of whom I lost two aged 19 and 21. [...] In these circumstances,
you will understand that it would be very hard for me to see to the affairs
other than in writing, the journey is expensive, and I could only make it
with difficulty, as I work without interruption. And so I dare to count on
your continued support, which I accept, although I understand that this
responsibility must weigh on you. [...]

It only remains for me to say that I share the admiration that you express
for a great artist, to whom one cannot apply the same standards as to a
mediocre being, and that I think of his death with the deepest sorrow, so
far away from all those who could have surrounded him if fate had been
less cruel.

Allow me, Monsieur, to express my heartfelt thanks, which I ask you to
believe.

Mette Gauguin

34, Kronprinssegade, Kopenhagen K (Denmark)

Eternité de la Matière —
Dialogue entre Téfatou et Hina (les génies
de la terre — et la lune.

Hina disait à Fatou; «faites revivre (ou
ressusciter) l'homme après sa mort.
Fatou répond; Non je ne le ferai point
revivre. La terre mourra; la végétation
mourra; elle mourra, ainsi que les hommes
qui s'en nourrissent; le sol qui les produit
mourra. La terre mourra, la terre finira;
elle finira pour ne plus renaître.
Hina répond; Faites comme vous voudrez;
moi je ferai revivre la Lune. Et ce que
possédait Hina continua d'être; ce que
possédait Fatou périt, et l'homme dut mourir.

From the manuscript *Ancien Culture Mahorie*, 1892/93, Indian ink and
watercolour on paper, Musée du Louvre, Paris, Fond Orsay

PICTURE ACKNOWLEDGEMENTS

The originals were kindly placed at our disposal by the museums and collections named in the captions, or else they derive from the publisher's archive, with the exception of:
(The numbers refer to the pages)

akg-images: 75
Albright Knox Art Gallery, NY/Scala, Florence: 30/31
Artothek, Weilheim: 60/61
Daniel Blau personal property: 2/3, 69, 71
Dallas Museum of Art: 22/23
Finnish National Gallery: 24
Ole Haupt: 10
Philadelphia Museum of Art: 28
Photographie Giraudon, Paris: 56/57, 58
RMN (Musée d'Orsay): 18/19, 36, 54;
 Jean-Gilles Berizzi/Hervé Lewandowski: 44;
 Hervé Lewandowski: 4/5, 29, 79
Collection Josefowitz, Lausanne: 51
The Art Institute of Chicago: 33
The J. Paul Getty Museum, Los Angeles: 41
The Nelson-Atkins Museum of Art, Kansas City, Missouri: Jamison Miller: 17
Yale University Art Gallery: 21

We have made every effort to identify the copyright holders. If there are any omissions, please contact Hirmer Publishers. Legitimate claims will be compensated according to the general terms.

TRANSLATED EXCERPTS WERE TAKEN FROM THE FOLLOWING SOURCES:

Paul Gauguin, *Briefe an Georges-Daniel de Monfreid*, Potsdam 1920: 74, 75, 78, 80
Paul Gauguin, *Avant et après*, Paris 1923: 182, 184

Published by
Hirmer Verlag GmbH
Nymphenburger Strasse 84
80636 Munich
Germany

Front cover: *Nave nave moe (Sacred Spring/ Sweet Dreams)* (detail), 1894, oil on canvas, Hermitage, St. Petersburg
Double page 2/3: Paul Gauguin (upper row, 6 from right) in Papeete, Tahiti, July 19, 1896, Daniel Blau personal property

Translation: Michael Scuffil, Leverkusen, Josephine Cordero Sapien, Exeter
Copy-editing/proofreading: Jane Michael, Munich
Project management: Rainer Arnold
Design/typesetting: Marion Blomeyer, Rainald Schwarz, Munich
Pre-press/repro: Reproline mediateam GmbH, Munich
Paper: LuxoArt samt new
Printing/binding: Passavia Druckservice GmbH & Co. KG, Passau

Bibliographic information published by the Deutsche Nationalbibliothek
The Deutsche Nationalbibliothek lists this publication in the Deutsche Nationalbibliografie; detailed bibliographic data are available on the Internet at http://dnb.dnb.de .

ISBN 978-3-7774-2854-3
Printed in Germany